IWM (Imperial War Museums) tells the stories of people who have lived, fought and died in conflicts involving Britain and the Commonwealth since 1914. Through the powerful stories and experiences in our unique collections, we challenge people to look at war and conflict from different perspectives. IWM's five branches are **IWM London**, IWM's flagship branch with five floors of exhibitions and displays; **IWM North**, housed in an iconic award-winning b██e world renowned ██ airfield; **Churchi**██rs below Whitehall; █████████████████████████████████████

G000060499

TANKS THE WONDER WEAPON

IWM's Film and Video Archive holds some 20,000 hours of moving image material. The First World War collection comprises over 1,000 films, mostly transferred to the museum immediately after the war. The museum's decision to collect this material was unusually far-sighted for the time, as film was not yet taken very seriously. After the war, public access to film clips was provided in the galleries on Mutoscope machines, which operated on exactly the same principle as this flip book. The film featured here is entitled *Tanks – The Wonder Weapon* and was shot in 1917. We do not know whether this film was one of those originally on display.

For more information on IWM and its Film Archive, please visit iwm.org.uk.

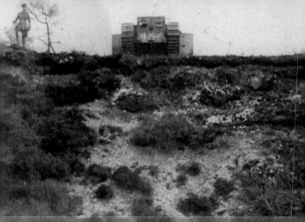

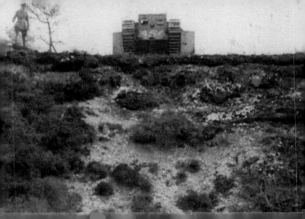

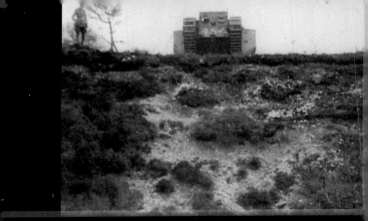

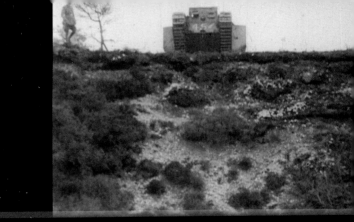

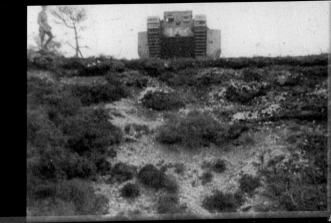

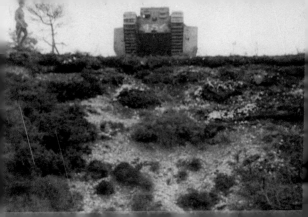

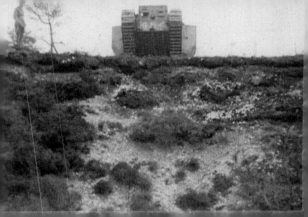

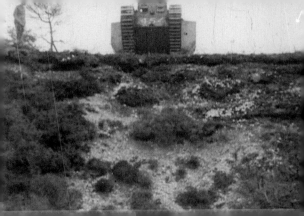

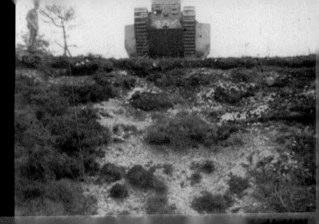

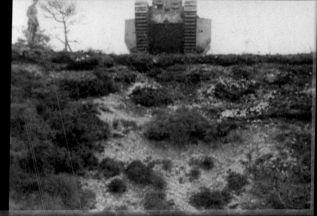

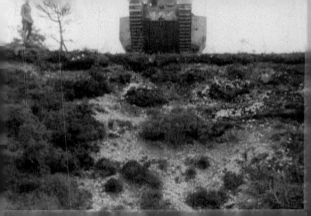

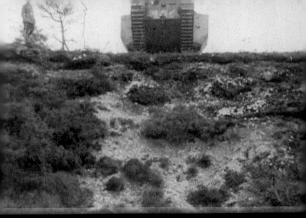

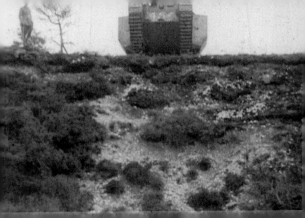

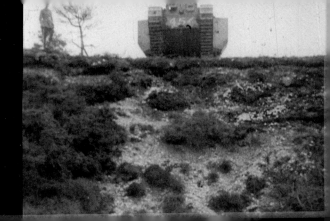

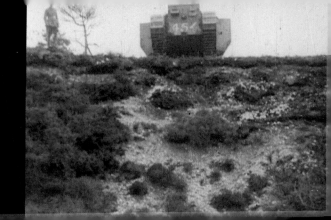

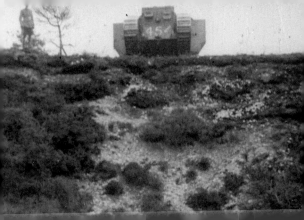

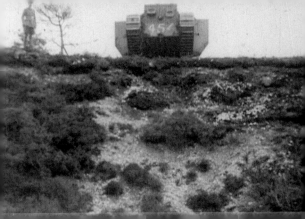

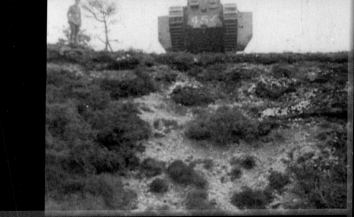

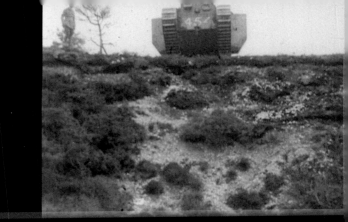

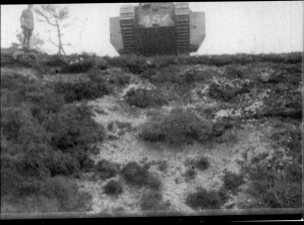

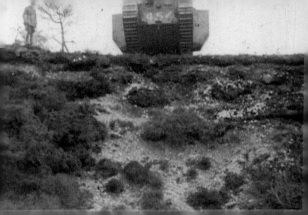

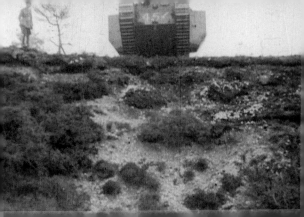

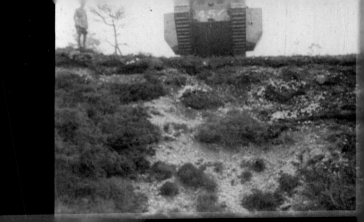

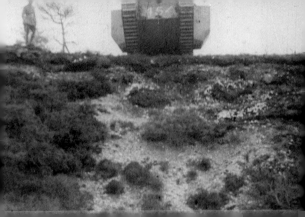

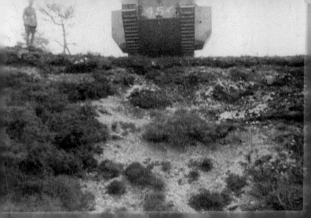

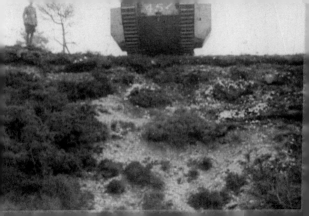

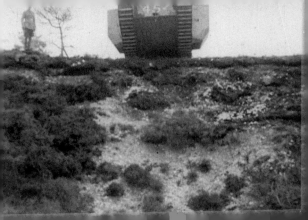

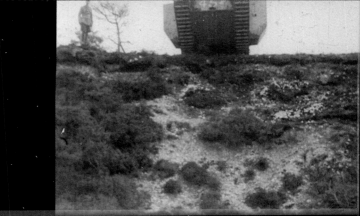

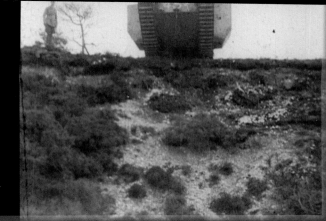

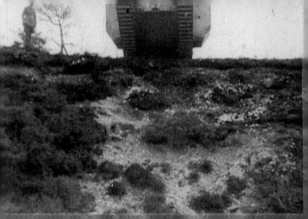

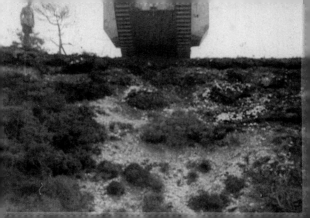

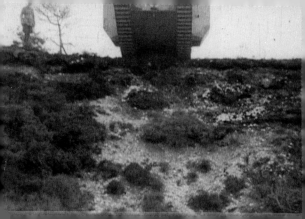

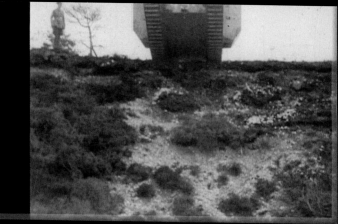

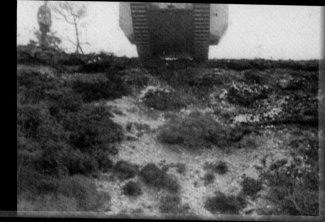

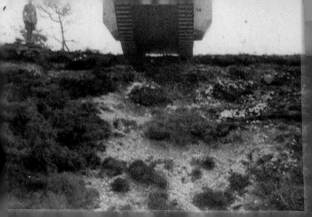

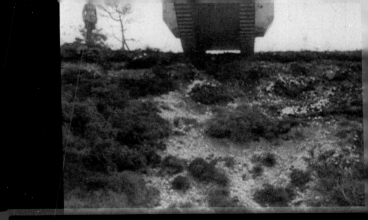

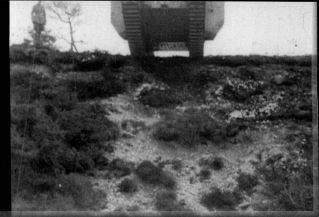

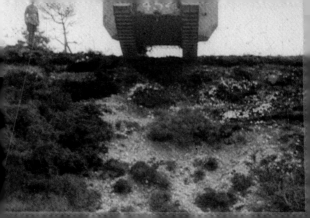

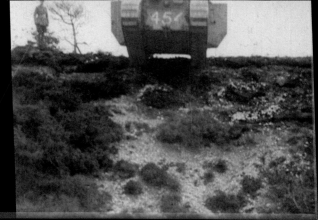

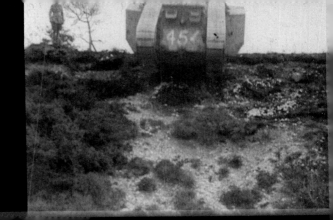

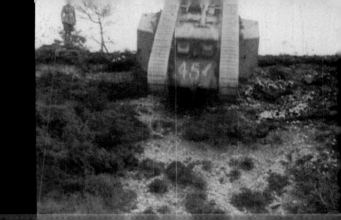

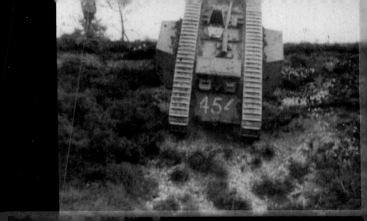

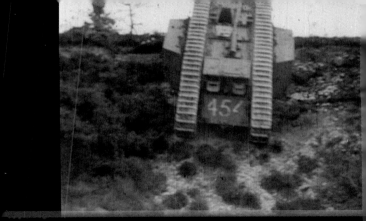

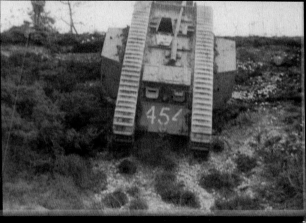

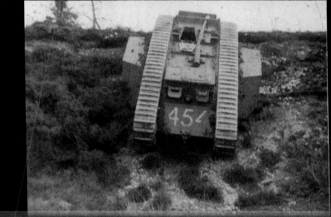

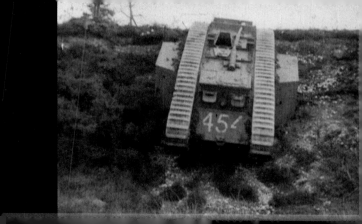

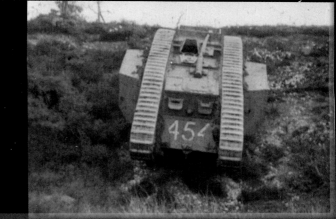

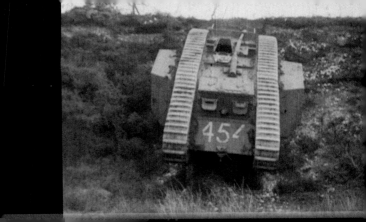

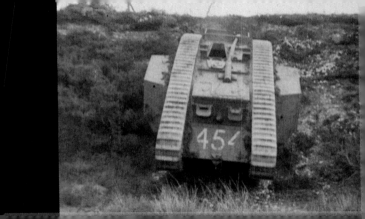

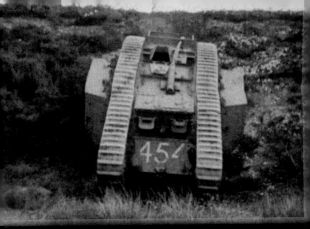

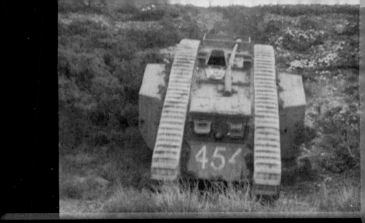

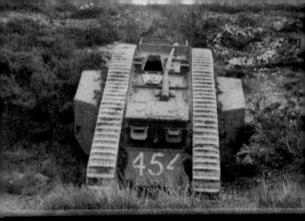

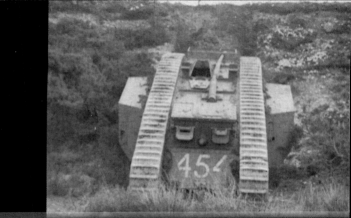

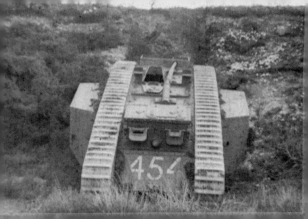

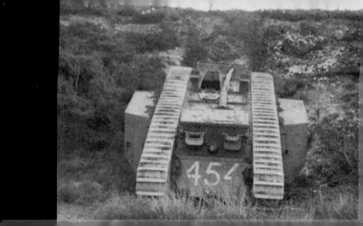

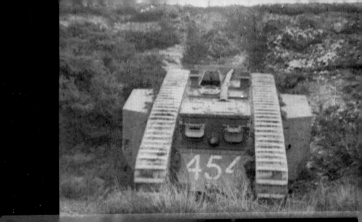

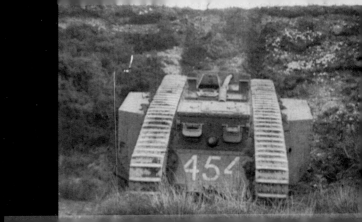

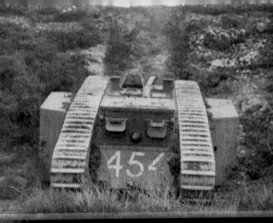

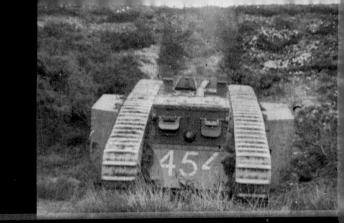

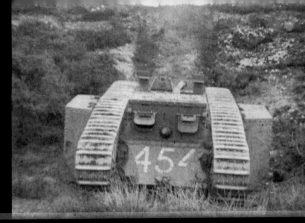

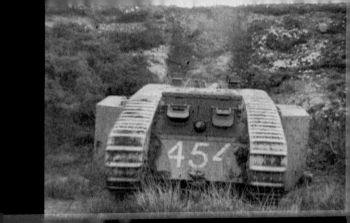

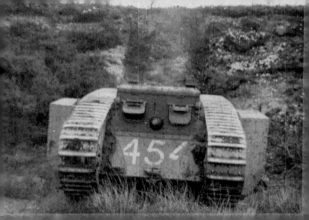

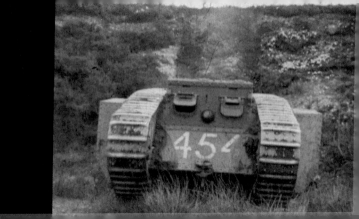

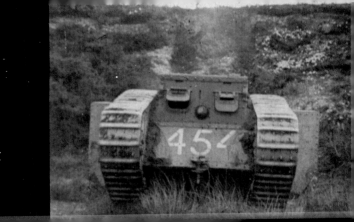

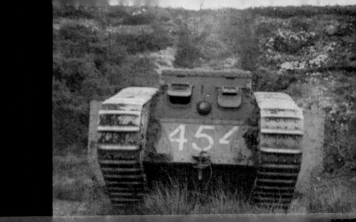

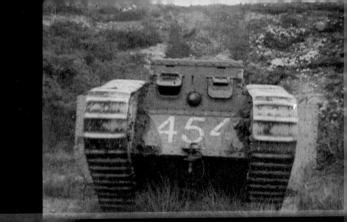

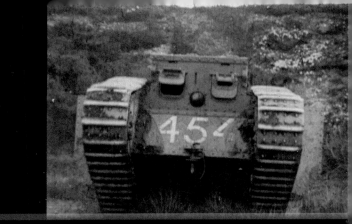

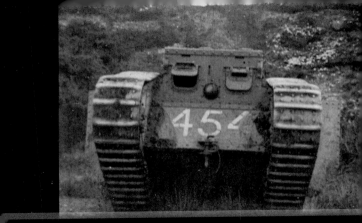

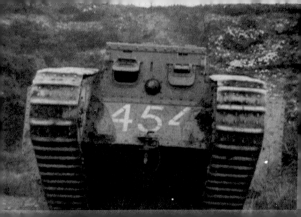

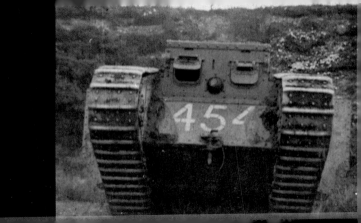

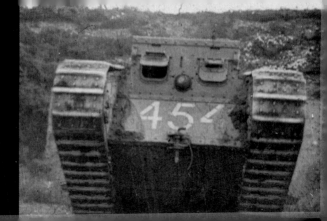

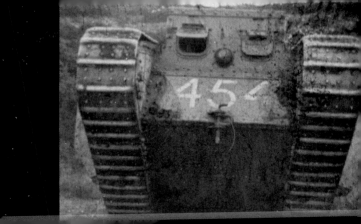

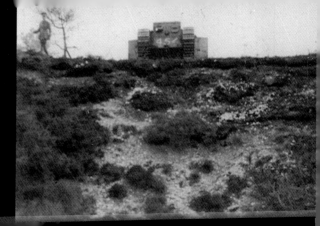

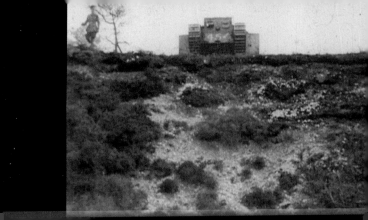

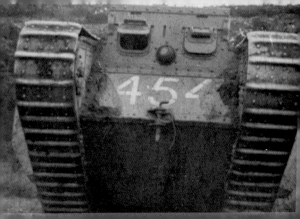

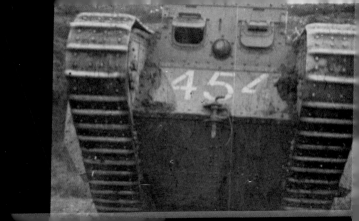

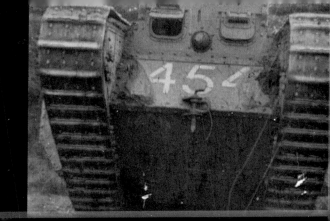

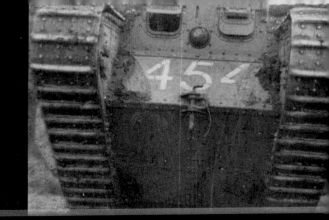